Christoph Noe

T0021835

How To Not Fuck Up Your
Art-World Happiness

Verlag für moderne Kunst

For my art-world crew

This book is a naïve attempt to make
the art world a little bit happier.

The idea for this publication came rather spontaneously in the summer of 2022 after gaining experience, discussing thoughts, and collecting anecdotes while working and living in the art world for the past fifteen years. It first developed foremost as a guide for myself as I continuously challenge the mission that I am on in the art world, asking myself why I am still doing what I am doing. Or sometimes, more dramatically, "If art is used in therapy, why do we almost need therapy when working in the art industry?" With a strong believe in the power of art and cultural creation and over multiple conversations and with the encouragement of my art-world crew, I came to the conclusion that these guidelines can function as a possible motivator, as a collection of thoughts or critical questions not only for myself but also for other people and collaborators working in the scene. Of course, many thoughts and tips can be seen as general advice regarding life, because—luckily—our life in the art world is inseparable from our life in general. Nonetheless, I tried to be specific to our context of living and working in the culture industry.

The advice presented within this collection oscillates between that for people seeking to enter the art world or just at the start of their careers (as once we all were) and that for seasoned practitioners who may be in need of some reminders. Also, the book addresses all actors in the art market: artists, art dealers, gallerists, art advisors, collectors, auction house staff, and the various people in the art service

industries who are not often on the front line. Having said this, I often view and tell things from my perspective as art consultant and collector. I can promise that all my thoughts derive from first-hand experience unless otherwise indicated.

There are a number of people I would like to thank for closely accompanying my journey in the art world, many of whom have had a strong impact on me and my doings, reminding me to be focused and persistent, to pursue my ideas, and to enjoy the sensation when a thought turns into reality. Many of them also often clapped— and I am confident will continue to clap—my shoulders. However, starting already here with the first piece of advice: Be prepared that more often than not, you will be the one clapping your own shoulders.
But in any case, we are in it together!

Christoph Noe
Somewhere in the art world, September 2022

TABLE OF CONTENTS

DON'T ART PARTY Ø1

Trust me, I have never made any new relationship after 11.30 pm at an art party that would turn out to be interesting—at least with regard to work. Keep things separate, especially in a world where private and professional are already so integrated. It is not a good feeling having to hide in your booth in Paris or desperately camouflage yourself in an Anish Kapoor wax installation during Biennale when the person you "ran into" at Frieze not so long ago passes down the aisle. The art scene is after all still tiny. Trade the art party for intimate gatherings.

The topic of collaborations and relationships will be a recurring theme in this book, and here I want to emphasize cultivating close people in your art network: your art-world crew. These should be people that you can trust without any restriction. People that give you open feedback. Intelligent people that you win respect from. People who offer you a place to stay when you waited too long to book your hotel in Miami or who would draw a mustache on their own VIP or exhibitor badge to get you in. Once you have found them, nourish the relationship, and don't let them go. They will be your safety net in rough times and the people to celebrate your success in good phases.

02 CULTIVATE VATE YOUR CREW

Being in art, we often hope for a creative journey in the pursuit of freedom and authenticity. And we love to present ourselves as creators, as supporters and preservers of culture, and as advocates of humanistic ideals. Also, most of us would agree that being kind and respectful in interactions with each other is a strong part of those ideals. In many cases, however, it seems we engage in a completely opposite behavior. You have got to accept that the art world is full of arrogant wannabes. The question is how do you want to present yourself? There is a choice. Live the values! And never abuse your power. Not the first but probably the loudest reminder comes from iconic DJ Scooter: It is nice to be important, but it is more important to be nice.

03 STAY HUM-BLE

04
FUCK WAITING LISTS

Sometimes I find myself wondering how grown, successful men and women accept such disgrace. If you are "taking interest," you are "not taking" my interest. It seems a peculiarity of our basic human instinct that the things we cannot get are what we want to possess the most. Or maybe this is our arty (and sterile) way to live out our kinkiness. Punish me! Make me buy two works just to get access to one! Let me lick your (so comfy and yet so repellent) On running shoes! Force me to find a museum for that one extra piece I had to buy! The same as waiting for a UK-bred labradoodle for 1.5 years while there are thousands of dogs looking for a new home, keep open to other talents. Like waves in the ocean, there is always a new one coming.

Probably a piece of advice that we also hear often outside the art world and a reminder I am giving continuously to myself. As much as I enjoy and use social media, there are also risks related to the algorithm: Very quickly, we create our own bubble where we get constant confirmation of what we know and have seen again and again. If you start to search for "abstract landscape," I promise you that this will be the new trend following you around from now on. Critical thinking becomes more challenging; but as we are in the art world and, per definition, should be open to new ideas and thoughts, be careful with it.

05
CHAL-
LENGE

YOUR
BUB-
BLE

One of my art friends is a more senior curator whose curriculum vitae includes some of the most well-known art exhibitions around the world. Why I admire her so much: She has kept her curiosity over all these years. We often meet people in the art world who give you the feeling that "they have seen it all." Not her. She is eager to explore art in different regions, to discover new practices, and to learn about the person and the story of the creator behind. And for all who need even more encouragement: If your mind stays young and curious, so does your outward appearance. And if we are not short of something in the art world, it is vanity.

06 STAY CURI-OUS

SWITCH OFF THE 07 NEWS

Being well informed is nothing to argue about. But where is the border between information and entertainment? How much do you need to know that helps you for your daily work? I am not talking about global news but only our industry news. Are headlines like "Paris Hilton launches new NFT collection" really a have-to-know item? Do we really have to think twice about whether Cleveland might become the new Venice? Or those ten "must-see" shows in a city that you have never been to and most likely will never visit? Unsubscribe from news-letters. And unfollow accounts that don't give you positive vibes. You will see how much more time you have for important things. Blend out more and focus on your own things.

DEFINE YOUR OWN 08 SUC-CESS CRI-TERIA

Many of us want to be successful in one form or the other. What does success mean to us and how do we define it for ourselves? Unfortunately, the common denominator in the art world in the 2020s seems mostly to be financial success. As Arne Glimcher said: "The most wonderful time to be in the art world was in the Sixties, because it wasn't a business—there was no business of doing art." Not to say the monetary aspect is not important, but when we qualify everything in financial terms, we lose that "richness" of art that made many of us decide to be in the art world in the first place. There is a risk that the meaning of a work fades behind its economic value. And there is no reason to assume that something is more important because it is numerically expressible.[1]

It sounds romantic, but can a touching comment by a show visitor not be a success criterion? The honest "thank you" to a collector by an artist for supporting a first show through buying works? Or the words from colleagues who are grateful and excited to work with you? Choose to measure success in how much others may benefit from your actions and contributions.

1 Rory Sutherland

Becoming a bit nostalgic: I remember one of the first times going to an auction house in London and listening to specialists' industry expertise. People that knew their stuff. People that published books. It is a very satisfying feeling to know that you have expertise in an area. There are old-school collectors that told me they had read every single book available on an artist, and I believe them. (On a side note, nowadays there are fewer books available, because people rarely bother to produce them since the artworks sell anyway.) Expertise is attractive and research can be exciting.

BECOME AN EX- PERT 09

ENJOY BEING ON THIS MISSION

10

This is probably my killer argument on a tough day when I question my role in the art world: You are taking part in cultural creation. And this includes so many roles and positions, from the artist to the shipper, from the registrars to the art publishers, as well as the curators and art writers. We can argue that art is not necessary but is a luxury—and we can fully argue the opposite: namely that art is most important, is something that differentiates us from other species, that preserves, challenges, and reiterates our values and beliefs. Art and culture continue to be an important platform for the exchange of ideas and thoughts between regions and countries, encouraging curiosity, generating interest, and creating conversations and eventually comprehension. Be proud to be on such a meaningful mission.

11
DON'T TRAV-EL 24/7

It sounds like a call to myself. There were times
when I felt I had to check off all the big fairs like
a tourist would check off the "Big 5" on a safari
in Namibia. Looking back, I question whether this was
really necessary. Of course, not everything can be
managed on IG, WhatsApp, or WeChat; and a personal
interaction with the artwork itself and personal meet-
ings are strongly favored. So two considerations:
1. Is it really necessary go to those places during the
fair times, or is it not more fruitful to visit galleries
at off-fair times? 2. Can some meetings, especially
the ones that would require long-distance travel,
not be moved to the digital realm in order to keep a
healthy balance?

Over recent years, the borders between art categories and creative disciplines have become more fluid. I am proud that our venture, LARRY'S LIST, was a small contributor to making this happen, providing a platform to enjoy and respect modern and contemporary art, collectible design, and mid-century furniture next to each other as a common experience. I have found lots of inspiration and satisfaction lately in contemporary design. It reminds me of my early days in the art world, in which not everything was market-oriented and when there was still the chance to establish a conversation with the artist. It can be refreshing to leave your turf and get inspiration from other disciplines.

12 LOOK OVER THE FENCE

When deciding to leave my corporate career, there was also the positive outlook to expect a different way of working, of being more in control of my own doings, of not having to report to the often-steep hierarchies. At the same time, the art scene is fragmented; often you will find yourself in small set-ups and—especially in the case of an artist—as a solo fighter. With all the freedom, it also means that you have to be your own motivator and have to clap your own shoulders to keep yourself going. But knowing all this, be also assured that there are many other people out there who know exactly how you feel and who are going through the same challenges. So take comfort in of the fact that we are not alone.

GET USED TO CLAPPING YOUR

13

OWN SHOULDER

APPRE-
CIATE
HUS-
TLING

14

This was the recommendation I struggled the most
to write down because it might sound conflicting to
my belief that you should do everything with full com-
mitment. However, this is not necessarily contradictory.
Some people can simply not afford to fully work in
the art world. There are many individuals who often
take up other roles to subsidize their life as an artist
and their artistic creations. There are multiple art
writers (unfortunately also a profession that is not
financially honored in any way) who take on other jobs
to live their dream. If you are fortunate enough to find
full-time employment in the art world, appreciate it,
and remember to show your respect and support for
those who are doing it differently.

With lots of activities, there is a diminishing marginal benefit. Is another hour really well invested? Art is life. Other activities can provide much inspiration for your work back in the art world.

15 REMEMBER TO UNWIND

MAKE
IT
REAL

While I would advise refraining from being ignorant, there is a fine balance as to how much feedback you should be listening to. Many people are overly interested in what other persons think, tailoring their actions solely to get other people's approval. I would argue that one secret today is fading out as much noise as possible. There is this book *Alchemy: The Magic of Original Thinking in a World of Mind-Numbing Conformity* by Rory Sutherland, in which he proposes that innovation can only happen if the same things are not repeated. Be confident! Make your own proposal! For me personally, it is one of the most amazing and satisfying feelings, when something that was only an idea turns into reality. Creating something always wins over not creating anything!

In the 90s, Berlin; in the mid-2000s, Beijing; today it's LA; and tomorrow, Seoul: the hotspots of the art world. We have seen the Leipzig School, Dansaekhwa, Hyperrealism, Cartoon Art, Figuration.... Do you still remember when Zombie Formalism was one of the hottest things and bubble gum on canvases was commanding millions of dollars? Some readers might not even recall any of those moments of hype. What do we learn? Nothing is forever and what is hot today might not be tomorrow.

17 WAIT FOR A WHILE

I am a true believer
that collaborations are
the key, not only in the
art world but also for
us as a species. Despite
all the risks of being
too open, too generous,
and of sharing too
much, especially in the
art world, we should
constantly remind our-
selves that we are in it
together.

18 BE GEN- EROUS

END
UN-
HEALTHY
RELA-
TIONSHIPS

19

Don't work with assholes, don't work for assholes!
What you lose through terminating a relationship is
compensated for by the level of freedom you will
win. And on that note: The biggest risk is to not take
a risk and to hang on to relationships that are not
healthy for yourself. I admit, these are a lot of
sayings for one short paragraph.

SAY NO TO GREAT CHANCES 20

Whether in the art world or not, when someone starts an offer with "This is a great chance for you," what they are really saying is "I don't have money to pay you." It is something I learned the hard way when writing my first proposals for museums, collectors, and private collections, then not winning the deal but seeing my ideas implemented later without my involvement or any payment.

Here is my advice to my art-consulting colleagues:
1. Ask if there is budget. Sounds simple but in my experience, this already sorts out three quarters of requests.
2. Have one meeting with the potential client and brainstorm initial ideas.
3. Tell them that you are charging from the second meeting onwards for your time.
And if the client hesitates to pay, Dr. Brad Klontz says it best: "Unfortunately, I can't take on any unpaid work to help you make money at this time. Thanks for thinking of me though!"

When there are 200 people on a waiting list trying to buy the same artist, why would you want to be number 201? Please send any explanations to answers@larryslist.com.

DON'T 21
BE JUST
A NUM-
BER

Maybe not as a daily routine, but I recommend that you ask yourself at regular intervals if you are on track and if you feel comfortable where you are. There is a risk of becoming too absorbed in one area or role and forgetting to step back and reflect on your current situation. There may come a moment when that dream of an in-every-sense-independent and always busy curator in a city, at a place that seemed promising and compelling ten years back, becomes less desirable than focusing maybe on family, or vice versa. Check in with yourself to calibrate and adjust your journey. If you feel unhappy for a long period of time, it might be time to change your route.

22 SCHEDULE SELF-CHECK-INS

Does this WhatsApp conversation look familiar?

8:15: Let's meet at 14.30 at the fair entrance.

14:18: Sorry, better at 15.30 at the lounge.

15:50: Sorry got stuck in a meeting.

16:55: Can do in 90 secs at the sushi stand.

17:18: Missed you. Let's try tonight at the party at Perrotin (see #1).

23:53: Sorry, maybe try again tomorrow before flying off.

And if the meeting actually happens, it is more than likely that one of you, if not both, will be continuously eyeing your phone not to miss any other "important" meetings.

I do treasure a bit longer talks and therefore recommend smaller events where everybody usually has more time to see the art, engage in conversations, and not be in a continuous rush to chase people.

23 GO SMALL

Never let anyone in the art world ruin your day. Ruin theirs first. The art world has a certain level of humor, yet you rarely see people laughing. Waiting outside a fair jostling to get in, only to realize thirty minutes later that it's the queue for the raclette booth instead of the Unlimited preview; hearing exactly the same story from about one dozen collectors, all of whom tell you separately that they were the very first one to collect a Robert Nava painting; spotting paintings executed in 2021 being auctioned in 2022 with the accompanying provenance "From an Important European (love-to-flip) Collection"; or when we #beforethestorm prior to a biz trip visiting two fairs in two week, we should look at it from the humorous side.

KEEP THE HU- MOR 24

25

WATCH

THE CO$_2$ FOOTPRINT

"That feeling when you buy a painting about ecology by a Brussels-based artist from a New York-based gallery at a Seoul art fair shipping it to your LA home."[2] Yes, the art world and CO$_2$ emissions do not always align easily. And being fully honest about it can hurt, the same way as realizing that your beloved Lululemon yoga shorts are in fact not made of recycled ocean plastic. I would always argue for IRL encounters; but at the same time, we could sometimes challenge our travel mode, our assumption that the artwork must be shipped overnight (knowing that more often than not, it will go directly to storage), and ask ourselves whether it could be sent in a consolidated shipment at a later date. It is time to question old routines and to be open for new approaches.

DON'T STRESS OVER THE PLATFORM

26

If you're not working as a social media manager or influencer, ask yourself whether you want to become an expert on the algorithm, or prefer to be an expert in your discipline or a master of your art and craft. Content and substance over noise! While we fully treasure and are grateful for what social media has provided us as a way of communication and means of connection, we always favor quality over quantity and encourage bringing conversations from the digital realm into IRL. Also, as mentioned before, everything follows trends and platforms come and go; but substance and artistic creation will remain.

Most art events are exhausting. You have to chat all day and night, spend countless hours on your feet, and eventually you even have to see some art. All of this is usually accompanied by irregular food and drink intake (not counting Prosecco and espressi) which doesn't help either. Plan ahead and prepare yourself with some healthy snacks. Here is our top list: Italian pistachio cookies that not only contain those essential fats but are ideal for sharing even with spoilt peers, protein bars that fit discreetly into a pocket or handbag for a quick fill, and finally a bag of almonds. Again, for the fats but also to leave a trail back to your hotel in Venice or to lead a wandering collector back to your booth to seal the deal (replace collector by influencer and seal the deal by get that post). And on this health note, a call to all gallery directors and owners: Get your collectors and equally your staff some acceptable seating options. It does not have to be an ergonomic office chair or a Cassina couch, but we have seen crates, book stacks and rocks (?!) that don't demonstrate hospitality and will cause back injuries.

LIVE
HEALTHY
DURING

27

ART
EVENTS

KEEP FRIENDS WHO ARE UNIM-PRESSED BY YOUR JOB

28

Have you ever attended a dinner where
you were the only non-physician? Or the
only non-lawyer? Surely, I also enjoy a
good dose of exchange in the community.
But as always, there is a hygiene factor
to see how much of our thinking, vocab-
ulary, and way of life is still compatible
with the outside world. The art world
can become inward-looking and detached
from real life. Friends from the outside
world will help you to stay grounded
and to get back to real-world problems.
Also, they will give you this needed look
when you tell them you are so "busy" and
"exhausted" from your travels around the
world for dinners and art openings.

There seems to be no limits on what to share. Does a studio visit have to be topped by a picture with the artist? Sometimes it looks like a hunter with his freshly-shot trophy deer, the only difference being that the studio visitor is—thankfully—not standing with his foot on the chest of the artist stretched out on the ground. All intimacy is killed. Think about that: Some of the most recognized dance clubs in the world preserve their atmosphere by banning photos and filming while on their property. The focus is on the here and now.

TREA-SURE PRIVA-CY 29

30 FIND A MENTOR

Something that can be relevant no matter the stage of your art career or your age. It sounds harder than it is; actually, there are many people who would be happy to engage directly or indirectly in conversation, or who would be open for advice and guidance on the way. I am grateful to have people in my network whom I can ask for advice or recommendations, or whom I can monitor from close proximity to see how they behave. And some of those people are not from the art world.

BE CARE-FUL WITH YOUR TITLE

31

My favorite collectors are those who call themselves "art patrons" after they ask for a 30% discount on a $5K artwork, pay in three installments, and demand free shipping. Like, do you wanna have fries with that too?[3] And in general, we are not shy of labeling ourselves in our industry where everyone can be an art dealer overnight by simply selling one clay vase on Etsy.

3 Inspired by Daniel Benjamin

32 BUCKLE UP

Even if your parents sponsored your Sotheby's or Christie's course, or at least you watched the entire catalogue of artists and art professionals on Masterclass, there will be the moment when you feel like Andrea Sachs in *The Devil Wears Prada*, and no PhD or whatsoever can prepare you for the situation of dealing with your first notorious boss. Here is a short selection of books and movies that will serve as a quick and dirty ready-for-the-job kit: *An Object of Beauty* by Steve Martin, *The $12 Million Stuffed Shark* by Don Thompson, *Seven Days in the Art World* by Sarah Thornton, and of course the series *Inventing Anna* that exemplifies beautifully that the art world is founded upon promises and dreams.

At the end of the day, it is a great privilege to be on this side of the (art) world and have the ability to work in this field. Be thankful for it. It could always be worse.

APPRECI-ATE THAT IT IS 33 NOT WORSE

34
KNOW WHEN TO KEEP QUIET

Sharing is caring, but sometimes it can be smart not to share and show everything immediately. To give you one example: We too often shared artists we liked on our Instagram, and then later on we had no more access to works of those artists ourselves.

The same principle applies the other way around; there is no need to always be criticizing and critiquing every artwork you cross paths with. Like your grandma might have told you, if you don't have anything nice to say, then don't say anything at all.

That was one of the most unique recommendations I ever received. The collection of German-Indonesian businessman Wiyu Wahono consists of works that incorporate living elements like plastic bags filled with live fish and mushroom cultures. He was very excited to say most of the works he bought directly lost value after purchase. Why? Because they cannot be or are very difficult to be resold. Once you accept that you cannot resell, you are fully free from the market and are able to enjoy the artwork as it is.

COLLECT WORKS THAT LOSE VALUE 35

36 BREAK PATTERNS

A typical art-world dinner goes like this:
30 min: Showing around IG artist accounts.
30 min: Discussing which artists you recently bought and who appreciated in value.
30 min: Revealing which artist you are trying to buy because they will appreciate in value (accompanied by some insider information that they will sign up with a certain gallery).
(0 min: Mentioning the artist whom you bought and who lost value)

We love market chitchat. But not always. And not always on the same topics. Next time, truly impress us and mention the name of an artist who resonated with you personally. An exhibition you visited twice. A curatorial concept that you found surprising. A moment in a museum when you were laughing because of joy.

With stakes running high, the art scene becomes painfully polished. Interview requests to young gallerists are forwarded to their external PR agencies, artists must first pass conversation requests by their dealers, with the result that conversations and behaviors become slick. Sometimes you don't know if it is an art gathering or a breakfast reception for the PWC "Auditor of the Year Award." I know what I am talking about inasmuch as I left the corporate world to end up few years later … in the corporate art world. I am not encouraging anyone to put on a performance, but am instead advocating an enjoyment of some direct answers, individual style, and original thinking. For example, emphasizing your addiction to neon-word artworks in your bedroom, wearing your commissioned, oversized gold necklace with the name of your favorite cheese, or accepting interview requests only during joint HIT training sessions is more exciting than any scripted Zoom call.

DON'T BECOME

37

TOO COR-PORATE

This is one for the newbies: If you are traveling to Art Basel, be reminded to book your accommodation early if you don't want to end up in the Best Western next to the Rheincenter in Rheinfelden (where the only benefit is that the *Schinkenbrötchen & frisch gebrühter Filterkaffee* breakfast will only set you back EUR 2,99.) Many years ago, we discovered the at-the-time newly opened youth hostel St. Alban Basel, combining a bargain price and an award-winning design. That tip should not have been shared too widely. From the second year, there was no chance to book it ever again. (See #33, Keep your mouth shut.)

BOOK 38 YOUR HOTEL EARLY

CREATE THE FUTURE 39

The art scene has been running without any need to change for a conservative estimate of at least forty years. But recently we have been witnessing changing environments: intermediaries being cut off, artists becoming more independent, established galleries taking on young artists, and so on. We can weep about the old times being over, or we can be curious about the change and, even more so, we can play an active part in the developments.

And I am not only referring to our comfortable life in the art world. Art folk are often in a unique position at the forefront of trends and developments, inasmuch as art acts as a radar of sorts for the things to come. Let's use that expertise and knowledge and make an active contribution to the discussion of how we want life to be in the future in general. Art is life. And there are a number crucial issues to be contributed to: the way of life in the digital space, private security regulations, and environmental issues, to name but a few.

QUESTION 40 VALUE-ADDS

Brian Eno made a point: "'Worth making' for me implies bringing something into existence that adds value to the world, not just to a bank account.... NFTs seem to me just a way for artists to get a little piece of the action from global capitalism, our own cute little version of financialization." I am far from criticizing either NFTs or a new technology, but I do also always encourage questioning what the value-add is. An old-but-still-relevant rule: Not just because a new medium or a new technology is employed does the content becomes stronger.

Possibly one of my most crucial pieces of advice that has saved projects, relationships, and deals in the past: Cultivate a strong network and warm relationships with people in the art service industry. To be precise, I am talking about art handlers, art insurers, restorers, and so on. Without a doubt, there will come the time when you need someone who can send you high-res images from a work in storage overnight, someone who can handle an urgent shipment from an artist studio in Milan to an art fair in London (and can get the belle arti export papers), or someone to help you to erect that 120 kg. marble statue in the garden on short notice on a boiling-hot Sunday afternoon. A big thank-you to all my supporters: you have saved me more than once.

41 BOND WITH ART SER- VICE PROVIDERS

BE AWARE OF ART BULL-SHIT-TERS

42

I am not talking about the "good deals" made by @gmail accounts offering to sell their collection of Cézannes and Monets for a price just 30% of the appraisal value. I am referring to every-day nonsense: all the galler-ists who keep telling us that EVERY artist in their program is the next superstar; the bank-er-turned-(NFT)-art-platform-founder who has this very new, very unique concept to sell digital art; the advisor who can get us a Nara (or replace Nara with Kusama) in twenty-four hours at a very reasonable sec-ondary market price; the ear-ly-retired music manager propo-sal of "starting an art gallery with a whole new approach to finding and representing talent that ensures the most promising young artists are supported ear-ly in their careers." Alongside my appeal to stay curious and respectful, be also respectful to yourself: value your own time and resources and be selective regarding which conversations you engage in.

Art is not only a career but often also
a lifestyle choice. With artists voicing
our inner thoughts, gallerists taking
our hard-earned savings, or art handlers
shipping some of our most precious pos-
sessions, it is natural that emotions run
high. This is also the beauty of it. At
the same time, be aware that if you buy
an artwork, you are not buying an artist
or a friendship. You may come to realize
that from year to year as you spend less
with a gallery, that your seat at their
dinner moves from the artist table to
close to the toilets to not being invited
at all. As John Deckmann wisely wrote on
one of his canvases: "How to spend your
whole life worrying about what other
people think about you only to realize
when you are old that nobody was think-
ing about you in the first place."

DON'T INVEST TOO MANY

FEEL-INGS

43

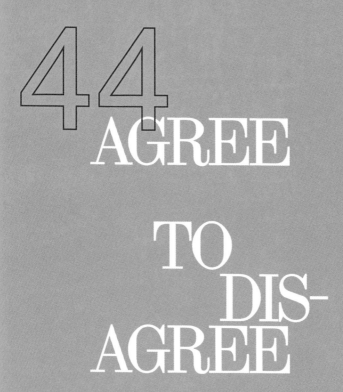

44
AGREE
TO DIS-AGREE

The way parents see their children's choices to pursue a career in the art industry has been a topic I have encountered repeatedly over the years. Unless you are blessed that your parents are collectors or have made careers in the art world themselves (or at least your mother had an affair with an art major back in university), from the day you announce your career choice to the day you win the Venice Biennale Golden Lion, it could be a topic of continuous conflict. It starts with "Is that art?"—which they probably asked you a thousand times—to "Have you met anyone nice?" (You made a critic hate you—does that count?). To a certain extent, we can understand that they're worried you'll end up moving to Berlin and getting some trendy spinoff mullet haircut. If only you worked for Marriott or Singapore Airlines, you could at least get them free trips around the world. You might be superproud of your new bottom-rung job at Hauser & Wirth, but what's in it for them? A free Rashid Johnson? Probably not. The solution: agree to disagree and acknowledge that some things might not align.

DON'T BUY THE WORK YOU SELL

45

Attention to all dealer friends: Do you know who actually owns or who is actually buying the pieces you are selling? This is critical, also because of the margin stacking that often correlates to the likelihood of making the deal real. Do conversations such as the following sound familiar? "I am not direct, BUT my colleague has a neighbor who goes for a walk every Tuesday with his dog and the dog of the actual owner of the work (who, btw, might already have consigned the piece to an auction house; not sure but can find out within seven to ten days)." Yes, there is a difference between "I know someone" (a phrase much too frequently thrown around in the art world) and having a proper relationship. Also, more transparency will prevent you from dealing with all those Gulbenkian & Cos. unless you're a risk taker and that is your art-world thrill.

My rule of thumb: One advisor for the seller and one advisor for the buyer is the maximum. Otherwise, you might end up buying the work you were offering yourself—just for 80% more.

With the chance to spend more time in Italy recently, there are a number of things I have observed. One of them is to embrace the moment and to enjoy the journey as much as the goal. What could be more enjoyable than having a warm and honest conversation with friends and like-minded people over a Spritz in the garden of the Triennale, at the local Chinese home-style cooking place dining on plastic stools, or on the stairs in front of an artist's studio with a warm Rotkäppchen Sekt (Berlin exclusive) and experiencing the feeling of togetherness? Appreciate the moments of this journey; often they will last longer than the goal itself.

EN-
JOY THE
DOLCE
46 VITA

Something not very easy in the art world where everything is about status and vanity. There are many people who achieve great things through hard work, endurance, and the resulting expertise. And there are equally as many who were simply in the right place at the right time or who started with privileges. Put things in perspective and give yourself credit for where you are.

BE NOT

47

BLINDED BY STATUS

EM-BRACE 48

DIVER-SITY

There is a major risk in the art world that the canon becomes very limited, that operations are overly consolidated, and that we always see, experience, and collect the same things over and over again—not only due to the Instagram algorithm but also when visiting major art events. Yet art is exactly the opposite. It is based on strong diversity and multi-facades, on regional and local offers. This applies not only to the art itself, but also to the supporting infrastructure of the scene. Work with the smaller framers next door, the one-man shipping company, read the blogs by an independent writer.

49 DON'T

OVER-EMPHASIZE PROVO-CATION

Provocation serves as an artistic tool and is "disturbing"—a word that may be found in assumably every other art-related press release. But very often it seems to be instead a technique to entertain the well-heeled art audience. If you want to experience something disturbing, consider a walk at night through Berlin's Görlitzer Park—fully without the safety net of a fifteen-euro museum entrance ticket. Superficial effects wear off and take away attention from subtle and less loudly articulated topics. This comes with a film recommendation: *The Square* by Ruben Östlund.

GIVE FREE HUGS 50

We spoke about your art crew
before. Here is some hands-on
advice about what you can do
to support them: Share their
shows, go to their openings, buy
their new catalogues (don't al-
ways ask for freebies; you also
buy things from people you don't
know), read their publications,
wear their merch, connect them
to your network, help them to
sell their works, give them men-
tal support when they need it,
organize tickets for them to at-
tend fairs, bring them to open-
ings, pay them a commission,
introduce them to journalists,
tattoo their iconography on your
forearm, ask questions and know
when to be silent, be generous
with your praise, hug them.

There is a widespread illusion that working in the creative industry means you are working creatively 95% of the day. Most likely the ratio will be other way around, so that admin issues and executing processes—like it or not—take precedence. I suggest having a set of tools available that make your life easier. Enter your new friend, Excel. An Excel pivot function that groups vernissage guests according to the number of their Instagram followers (replace by net worth) often still does the trick and will impress a senior sales director as much as the VP of the corporate art program.

51 MAKE FRIENDS WITH EX-CEL

A small anecdote about a guy who ran a gallery
in Hong Kong a few years back: On top of the
commonplace gallery reception desk which is
so high that the staff behind it disappears,
he installed a matching wall descending from
the ceiling that left just a narrow gap through
which to see the receptionist. And this gap was
at such a height that if the receptionist didn't
stand, was less than 160 cm. or over 165 cm.
tall, it was impossible to see their eyes. I was
never clear if this was his way of playing with
the stereotypes of barriers in the art world or
simply of reinforcing them.
But to come back: In the beginning it takes a
bit of courage to engage in the art scene as
a newbie. But once you start using the words
"juxtaposing," "articulation," and "preconceived
values" fluently, you will do just fine.

ARTIC-ULATE

52

PRECON-CEIVED VALUES

What screams more that you are an artist, curator, or gallerist than a painstakingly put-together, purposefully eccentric outfit? How about being successful at your art world job, receiving a glowing review because you put together a fresh new show or training your artistic eye through hard work and research to be able to spot the latest trends and meaningful developments? In my experience, the simplest people on the outside have been the most creative and the most influential. If you are good at something, you don't have to prove it to anyone, so take it easy and keep your profile low.

KEEP YOUR PRO-FILE LOW

53

BRING YOUR 54 RUNNING SHOES

This is not because the money-conscious collectors will ask you to personally deliver the 100-kg. bronze statue to their fourth-floor walk-up apartment after the fair ends (a no-no, I hope I needn't say). There are many other reasons: to trade a night out for an early morning run, to explore the city beyond just the convention center, to change a brainstorming session with a colleague from yet another coffee to a jog around the park, or to simply walk back to the hotel when someone snatches the last cab in town.

55 CHECK YOUR FOMO

Over 300 art fairs per year, triennales, biennales, art weekends, daily new on-line shows, nearly 150 gallery openings on a single weekend in May in London: You won't be able to make, see, party, post on all. There could be whole books just on the art world and FOMO. Instead, here is a quick self-test. If you tick two or more out these common signs, you're officially a victim of art FOMO:
- You do live updates of your ride on a vaporetto to the Biennale.
- You get worried if you don't hear from your gallerists at least once a week "Nothing available."
- You share live stories of all the most important works (wrong: not works but actually the most important people you met) during the fair preview.
- You RSVP to literally all events you are invited to.

"I want it all! I want it now!" Queen's song from 1989 seems to be written for many figures in the art world today. Why not create something first and let things develop before it is screamed out to the world? How about posting the artwork you just collected after you actually settled the bill for it? Often short-term targets contradict with mid-term achievements. The instant gratification ends up taking away energy from creating something more substantial and meaningful.

DON'T FIGHT THE WAR FOR ATTENTION

56

57 BE STREET-SMART

Some deals really are too good to be true. The dealer you only know from your DMs who offers you a bargain but somehow never manages to forward you high-res images of the painting, or that institution that is very motivated to exhibit your works and later sends you price lists for everything from the space rental fee to hors d'oeuvres. In most cases, your stomach will have told you already to be careful, and yet the more promising it sounded, the more likely you would have fallen for it. Recently, after being enticed by false promises, two colleagues were on the verge of closing their galleries after their IG accounts got hacked (okay, they shared the logins a bit naively). As the saying goes "If it looks like a duck…." Learn from their mistakes and apply the same street smarts to the art world as you do in real life:

- Withstand the temptation of clickbait. Following links like "Congratulations, if you click here your IG account gets verified" never results in that coveted blue tick.
- Double-check bank account details via different channels. Phishing companies consciously target the art industry because of our gullible eagerness to do business.
- While the sale of a million-dollar company usually requires proper due-diligence, or the sale of a house a notarial contract, artworks of similarly high values are not unlikely to be sold via an IG DM. Easy! But a proper contract and escrow account might save some sleepless nights.
- And backup your hard drive regularly. Do it now, thank me later.

One thing that is a certainty in the art world: Sooner or later you will encounter a proper crisis. There are the personal ones like putting the wrong date for the opening in the email header after checking it a dozen times or mixing up currencies at an art fair in Seoul and selling in Won instead of USD (the other way around, it could have gotten you a promotion). But there are also the big, dirty, possibly neck-breaking ones: One of your museum's patrons was ousted for having made his fortune trading arms; a golden toilet was stolen from the exhibition venue; or the wallet with the corporate digital art collection got hacked. Your time to shine: Prepare yourself with a BA in psychology, a previous job at BP, or any position with Boris Johnson. This will furnish you with some solid experience on how to handle art world wars.

58 PRE-PARE FOR THE CRISIS

DON'T UNDER-ESTIMATE THE TOTE BAG

59

Probably one of the most obvious signals and (life-)style signifiers in the art scene: the beloved and therefore ubiquitous tote bag. Already from afar, it informs the "audience" about the wearer, from latest art travels to art-world status: the bright yellow Design Miami bag = VIP, 032c = (wannabe) art critic, discounter brand bags like Aldi = don't care but actually do care, the Shrigley tote = champagne lover, Documenta II = my clock is ticking. While we still have not figured out where all those bags collected over the decades end up (don't consider this as a hint to use for an art installation), I advise being careful with your choice of tote bag: the art scene is full of codes and unwritten laws.

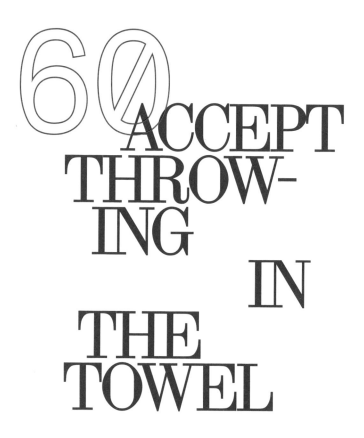

60 ACCEPT THROW-ING IN THE TOWEL

Don't blame a clown for acting
like a clown. Ask yourself why
you keep going to the circus.
And if it is time to go, say your
farewells with grace.

IM-PRINT

Editor: Christoph Noe
Editing: Jamie Bennett

Supported by: Jamie
Bennett, Arianna
Ambrosetti, Cordelia
Noe, Summer Tsui

Produced by: LARRY'S
LIST

Design: Raphael Drechsel

Published by:
VfmK Verlag für moderne
Kunst GmbH
Schwedenplatz 2/24
1010 Vienna, Austria
www.vfmk.org

4th Edition
ISBN 978-3-903439-70-2

Distribution:

Europe: LKG,
www.lkg-va.de

UK: Cornerhouse
Publications,
www.cornerhouse-
publications.org

USA: D.A.P.,
www.artbook.com

Bibliographic infor-
mation published by
the Deutsche
Nationalbibliothek

The Deutsche National-
bibliothek lists this
publication in the
Deutsche National-
bibliografie; detailed
bibliographic data is
available in the Internet
at dnb.de